Needle Felted Figures

Bodil Nederby

SEARCH PRESS

Contents

Foreword

Wool, a felting needle and a foam rubber punch pad – that is all you need to create these cute and fun little creatures. This book contains the inspiration for many hours of fun. This is a hobby that is suitable for children aged five and upwards (with the help of a grown-up), and believe me, felting using a felting needle is not just for girls – boys can also get involved. The important thing here is patience, interest and fine motor skills rather than age and gender.

This book contains in-depth descriptions of the basic techniques and a range of patterns for ingenious model figures.

You can follow the patterns as closely as you like, or you can adapt the designs by using different colours or making them in different sizes or in different proportions. You can also make different ears, eyes, etc. and the figures can be made smaller or bigger than those in the book. It is quicker to make a small figure than a large one, though you can put more details on a large figure. In short, it is up to your own creativity and imagination. Have fun!

Bodil Nederby

List of models

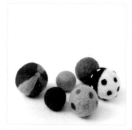

Balls, page 16

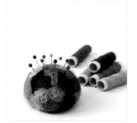

Pincushion made from remnants, page 18

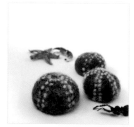

Fossilised sea urchin, page 20

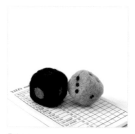

Dice, page 22

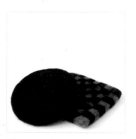

Placemat, page 24

Flower brooch, page 26

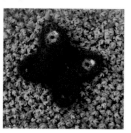

Butterfly brooch, page 27

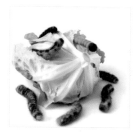

Caterpillars, page 28

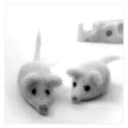

White mice, page 30

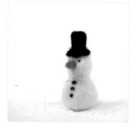

Snowman, page 32

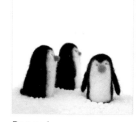

Penguin, page 34

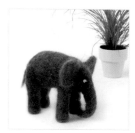

Elephant, page 36

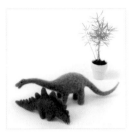

Long-necked dinosaur, page 38; Stegosaurus, page 40

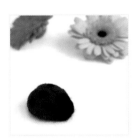

Ladybird, page 41

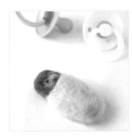

Baby in swaddling clothes with bonnet, page 42

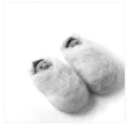

Baby wrapped in blanket, page 44

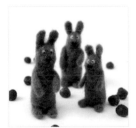

Hare, page 46

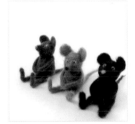

Three small mice, page 48

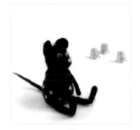

Mouse with pants, page 50

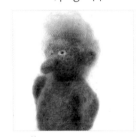

Troll, page 52

Troll with clothes, page 54

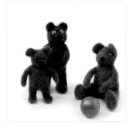

Little bear (without clothes), page 56

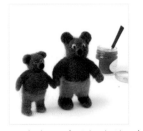

Little bear (with clothes), page 58

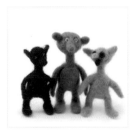

Martians, page 60

What you will need

To make these models you will need the following:

- A foam pad, e.g. 20 x 20cm (7¾ x 7¾in) and at least 5cm (2in) thick. You should be prepared for the fact that the needle will gradually pull small pieces of foam out of the pad. Once these small pieces of foam start to get picked up and mixed in with the wool, you will have to replace the foam pad.
- A felting needle. These are available in various sizes, and the models in this book are made using the most delicate or finest needles – you will just have to see how you get on.
- You might need a needle holder. Various models made from wood are available, though you can also use a cork: make a hole by pushing a nail through the cork, then carefully push the felting needle into it – but not all the way in. The top, angled part should be left sticking out of the top, making it easier to grip hold of with pliers when the needle has to be replaced.
- Carded wool is hair cut from sheep – in other words, wool. This has been washed, carded (brushed through) and dyed. Carded wool is available in various qualities, and some are easier to work with than others. This depends on the breed of sheep and whether or not it has been combed, amongst other things.
- If the wool has been combed, this means that the fibres are nicely aligned to form long strands and this wool has a finer structure. If the wool is uncombed (tangled), this means that the fibres are less orderly. This wool has a coarser structure. It is easy to use for needle felting and therefore preferred for this purpose. If you have some carded wool that is too 'smooth', you can 'ruffle' it up before starting work to make it easier to work with. For the sake of simplicity, carded wool is just referred to as 'wool' in the instructions.

The felting needle

In this book, the process of felting is described as 'needling'. This expression is used as it is the most appropriate term in this context and immediately understandable. Since the felting needle is extremely thin, it is very easily bent or snapped. To avoid this happening, you should observe the following rules:

- Always insert the needle straight down and remove it by pulling it straight up, or diagonally in and diagonally out. In other words, in and out in the same direction.

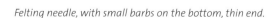

Felting needle, with small barbs on the bottom, thin end.

- Never wiggle the needle while it is in the work piece or in the foam pad.
- When you are not using the needle, it is a good idea to stick it vertically in the foam pad and leave it there until you need it again.

In the photo you can see the small barbs on the felting needle. It is these that catch on the wool fibres and tangle them together when inserting into a clump of wool. Doing this repeatedly makes the fibres become more and more entangled, making the clump of wool smaller, firmer and eventually really hard.

The barbs are critical, as this is where the felting process occurs. In other words, if you are applying an extra layer of wool on to a ball, there is no point inserting the needle all the way to the bottom (if the ball is already as firm as it needs to be). It is enough just to needle into the surface of the ball for the new layer to be firmly attached.

Different colours of carded wool

It may be a good idea to invest in different colours of carded wool. As well as experimenting with different figures, it is also fun to play with the colours.
Keep the different colours separate by putting them in their own bags. You might also want to keep another bag of mixed colours, where you can put all the small scraps that you are bound to get.

'Clumps' and 'tufts'

In this book we will be using the terms 'clumps' and 'tufts' of wool. There is no clear definition of what a 'clump' or a 'tuft' is, other than that a clump is bigger than a tuft.
The term 'clump' is used for the portion of wool that you start with to make a ball or a 'sausage', for example.
A 'tuft' is smaller and it can vary in size from a small tuft, for example for eyes, to a slightly larger tuft, for example for ears.
A 'tuft' is also used to describe the portion of wool used to create an extra layer.

Once the ball or the figure is firm enough, just needle into the surface to attach more wool.

How to obtain a 'clump' or a 'tuft' of wool

Never cut the wool!

As has been explained, carded wool is made up of long fibres of wool. The process of felting helps these long fibres to become tangled in each other. If you cut the wool you risk making these fibres so short that they cannot become entangled.

Ugh! This takes a lot of strength. *This way is easy!*

My long hair gets tangled. *My short hair does not get tangled.*

Do as follows: spread out the wool fibres a little, and take hold with both hands. Make sure your hands are not too close together, but ideally 10–15cm (4–6in) apart. Pull your hands apart and what you will have is a 'clump' or a 'tuft'. (To see the difference, try holding your hands close together instead and then pull!)

Shaping the wool

Take a clump of wool and place it on the foam rubber pad. It is easier to shape the wool if the fibres are not too tidy and too closely packed together. If necessary, spread the wool out a little and then gather it up again so that it is in an untidy soft clump.

The wool compacts in the direction in which you insert the needle. If you needle into a clump of wool repeatedly without turning it, you will end up with a flat 'pancake'. If instead you turn the clump of wool evenly and needle into it from various angles, you can form the wool into lots of different shapes. If this is your first attempt at shaping wool, it is sensible to start off with a ball. This will give you a good idea of how much the wool shrinks and becomes firmer – but also how you shape the wool. As has been explained, the wool shrinks as you felt it, so in other words the clump of wool that you start with must be bigger than the desired end result. How much bigger is hard to say in advance, since it depends on how firmly you felt it, amongst other things.

If you are unsure how big or small a clump of wool you should start with, then it is better to begin with a clump that is too small rather than too big. You can always add more wool to make it bigger, whereas you cannot take any wool away once it has been needled into place. You just have to proceed by trial and error and learn – both from your successes and your mistakes.

If an attempt to make a particular figure does not work out, you can always use it for a different figure – so do not throw it away!

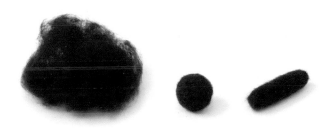

Here you can see a clump of wool and how much it has shrunk after felting to produce a small ball or a small sausage.

A 'sausage'

Take a clump of wool and spread out the fibres. Loosely gather it up again into an elongated clump of an even thickness but with the fibres inside arranged irregularly. Now needle into it from all sides and all the way round. Also needle into the ends so that it becomes 'closed'. Remember that the finished sausage will be smaller than the clump that you started with. The figures in the book

are needled relatively firmly, so to make a sausage that is 6cm (2½in) long, for example, you will need a clump of wool that is 11–12cm (approx. 4½in) long.

If the sausage turns out too thin or too short, add more wool, but do this before the sausage has become too firm. If the sausage is both too thin and too short, you can make it longer and thicker at the same time by applying an extra layer to one end and along the sides to the middle (being careful not to tighten it) and needling it in place. Do the same at the other end.

If the sausage is too long, then it can be made shorter but you have to do this before it has become too firm. Needle diagonally into the sausage (instead of vertically) and also needle into the ends.

An extra layer

It says in a number of places in the book that you can 'apply an extra layer of wool'. It should be made clear that this does not just involve applying wool, but also needling it into place. If you want to apply an extra layer of wool, whether this means making a ball a bit bigger, or making one leg thicker than the other, there are two things you must remember:

· Do not take too large a tuft! It is easier to work with a smaller tuft, and you can always add more wool if you have not used enough in the first place. If you use too much, you will not be able to remove it once it is needled in place. It is also easier to achieve a smooth join if you just use a little at a time.

- Do not apply the tuft of wool too tightly! Just apply it loosely and leave it like that while needling it into place. There has to be something for the needle to work with and take down into the work piece, and it cannot do that if the wool is applied too tightly.

Edges and individual fibres sticking out

When forming an edge, for example for an eye, it can be difficult to get hold of all the fibres with your needle. This is how to do it:

- Use the needle to bend the fibres carefully in over the edge and then needle them into place.
- Individual long fibres: 'catch' them by twisting the needle around them and then inserting the needle into the wool. You can of course also use this technique to make a dot, for an eye for example.
- If it is the edge of a shirt, for example, which has to be clearly defined, you can apply an extra layer of wool (making sure you do not apply it too firmly) and needle it into place. Also needle into the edge in the same way as if you were making a flat shape.

Identical pairs (eyes, ears, arms, legs)

When making a pair of ears, for example, it can be hard to know exactly how large a clump of wool to use. You should therefore start with two tufts that are the same size and make an ear out of one tuft. If this ear turns out

too big, then you know that the other tuft is also too big. So, take a little wool away from it and take a new tuft of the same size, then make a new ear from this piece. If it is the right size, then you can be sure that the remaining piece is the right size for the other ear. On the other hand, if the first ear is too small, then just add more wool. Eyes can be a bit more difficult because it involves working with such small pieces of wool – sometimes just a few fibres. If an eye just does not work, you can very often pull it out again and make a new one.

Attaching pieces

When you make noses, ears, arms, legs and such like, they should not be needled and 'closed off' at the end that is to be attached to the figure. This is because you need some loose wool to attach it by.

A sausage with loose wool at one end for attaching it.

Noses and snouts

Make a nose (or a snout) in the right size and shape for the figure you are working on.

Attaching the nose: Spread the loose wool out to the sides. Place the nose roughly in the middle of the face so that the loose wool spreads over the cheeks, forehead and chin – then needle it into place, working all the way round. Also needle diagonally in through the nose and down into the face.

To make a tip on the end of a snout, simply make a small ball and then needle it on to the end of the snout.

For a beak, for example, which is a different colour to the rest of the face, instead fold the loose wool in. You can then attach the beak by needling straight through it and down into the face, again working all the way round.

Eyes

There are three ways of making eyes:

- You can create a small hole, by inserting the needle into the same place repeatedly.
- You can also make a small dot out of black wool. This type of eye is particularly suitable for small figures, though not for figures that are black or very dark. See also 'Edges and …' on page 10.
- First make an eye out of white wool and then make a dot on this out of black wool. The advantage of this method is that you can make different facial expressions. Here are a few examples (you can experiment yourself with more).

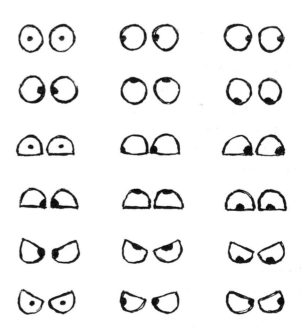

Mouths

Many figures simply do not need a mouth – the eyes are enough to bring a figure 'alive'.

However, if you do want to make a mouth there are also a number of ways of doing this:

- Repeatedly insert the needle where you want the mouth to be. This creates an indentation or a groove.
- Take quite a small tuft of black wool and stretch it out slightly to make it longer and thinner. Then needle it into place in a small line where you want the mouth to be.

Here are some ideas for different types of mouths:

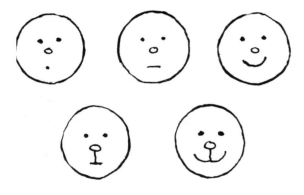

Ears

There are a number of different shapes for ears. They can be large or small, round, elongated or pointed, etc. They can also sit on the side or on the top of the head.

How to make an ear: Take two tufts of wool and first needle one tuft into a flat 'pancake'. Needle both surfaces and also round the edge in order to form it into the

desired shape. Remember not to needle all the way round – you have to leave some loose wool where the ear is to be attached to the head. Next shape the other ear in the same way. See also 'Edges and ...' on page 10.

Attaching ears

- If the ear is supposed to stick out, like on a teddy bear for example, then bend the loose wool back (towards the back of the head) and needle it into place, working all the way round. If necessary apply more wool in order to reinforce the join and to smooth out any irregularities.

- If the ear is supposed to lie against the head, like on a person, then bend the loose wool forwards (towards the cheek) and needle it into place.

Legs

Start in the same way as for a sausage. It needs to be a bit thicker at the top of the leg and make sure you do not needle the last 1–3cm (½–1¼in) of wool. The wool here has to be loose so that there is something with which to attach it to the body. Needle into the leg at the foot end to close it off.

Legs without feet

Whichever type of animal you are making, you can leave the foot rounded (like at the end of a sausage) or you can needle into it to make it flat.

Legs with feet

If you are making a figure with two legs that is supposed to stand up, it is important that the bottoms of the feet are flat and that the feet are not too small. It is also important that the figure is quite firmly needled. The individual parts should not be too firmly needled at first, but only once all the parts have been assembled and the figure is taking its final shape.

Method 1:

Make a leg as described above. The 'sausage' should be firm but not hard. Its length should be the length of the leg plus the length of the foot, plus the loose wool for attaching it to the torso. Remember that the leg will be shorter than the tuft of wool that you start with.

'Bend' the leg at the ankle and insert the needle repeatedly in at the heel. Add a small tuft of wool to the ankle and gently needle it into place. Next needle in from all sides so that the leg keeps its shape while at the same time you form the foot (which must be flatter at the toes than at the ankle). Add more layers if necessary to give the foot and the leg the right shape and thickness, and so ensure that they are as firm as the rest of the figure.

Method 2:

Make a leg as described above, but do not needle it at either the top or the bottom.

Next, attach a flat 'pancake' in the shape of a foot and the right size and thickness for the leg. Spread out the loose wool at the foot end of the leg. Place the leg on the foot, gently fold the loose wool around the foot and needle it into place. Add more layers if required and adjust the shape, size and firmness to match the rest of the figure.

Attaching legs

(In this case it is two legs, but the principle is the same for an animal with four legs, in which case you will need to make sure that it rests on all four legs.)

Start with one of the legs. Spread out the loose wool at the top of the leg and place the leg against the torso. Gently spread the loose wool out over the hip (making sure it is not too tight) and needle it just a little into place. Do the same with the other leg.

Adjust the legs relative to each other and look at the figure from all angles to check that the legs are positioned properly. At this stage you can still move the legs around a little, or even pull them off and replace them – you will just have to proceed by trial and error.

Once they are more or less where they need to be (it is all right if they are a bit 'lively' until they have been needled into place) apply a few more layers (making sure they are not too tight) around the top of the leg, the crotch, hips, stomach and bottom – just like putting a nappy on a baby. There are three reasons for this: first, it makes the figure more solid and so more stable. Second, you can adjust the shape and, for example, apply extra wool to the stomach, bottom or tops of the legs if these need to be filled out. Finally, you can even out any irregularities. Make sure that the firmness is even and also check the feet.

Arms

Start in the same way as if you were making a sausage, but at one end (where the upper arm is going to be) leave the final 1–3cm (½–1¼in) loose – so that there is something with which to attach the arm to the body. The other end, where the hand will be, can be needled flat if need be.

If the arm is supposed to have a bend in it, you can bend it a little and then needle into the inside of the curve.

Attaching arms

First of all decide which way you want the arms to turn. Hold them against the body and try them in various positions. Are they supposed to hang down, be lifted up in front of the face, or bend in towards the stomach? Perhaps they should be bent in different directions? What goes best with the facial expression and the rest of the body? Once you have made up your mind, you can start to attach the first arm: spread out the loose wool and place the arm at the shoulder so that it bends in the desired direction. Gently spread the loose wool out over the shoulder (making sure it is not too tight) and hook it into place. Apply more layers, both in the armpit and around the shoulder and upper arm to make it more stable, but do not needle it firmly into place just yet. Now do the same with the other arm.

Have a look at the figure from all sides. Check for example that the shoulders are the same size and at the same level. Are the proportions right compared with the rest of the body, etc.? Add extra wool wherever it needs filling out: the chest, shoulders, neck, upper arms, etc. Finally, if required apply another layer in order to even out any irregularities.

The models

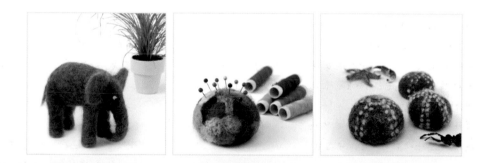

Balls

Weight: 3–15g (0.1–0.5oz)
Diameter: 3.5–5cm (1½–2in)

What you will need:
- Wool of the required colour(s)

Instructions:

Take a clump of wool and spread the fibres out. Loosely gather it together again into a clump with the fibres in all directions.

Needle into it from all sides.

Keep turning it and needle into it wherever it bulges out. It requires a little patience at first while it is still shapeless, but slowly it will start to take shape and become firmer. If it is uneven, or if you want the ball to be bigger, you can apply more layers. Also check that it is of a uniform firmness. If it is softer in any one spot you will have to needle it a bit more.

Once the ball is of the required size and firmness, you can decorate it with stripes, spots or whatever you like. Finally, if you want to you can moisten your hands and roll the ball between them to ensure that the last few wisps of fibre are lying flat.

NB: When the ball starts to become hard (it can actually get as hard as a tennis ball) do not insert the needle too deeply as there is a considerable risk of snapping the needle. Only insert the needle into the surface of the ball. See 'The felting needle' on page 6.

Spots: Take a small tuft of wool of the desired colour and needle it to make a small spot. Making spots on a ball is a really good exercise in accuracy, both in terms of size and location. See 'Edges and ...' on page 10.

Stripes: Take a small tuft of wool in the desired colour, apply it loosely to the ball and needle it into place. To make the stripe even, use the needle to push the fibres carefully in along the edge and needle them into place. If the first layer does not cover sufficiently, you can apply more wool.

Orange ball with stripes:

1. Make an orange ball.
2. Needle two yellow spots, one at each 'end'.
3. Needle a wide turquoise stripe from one of the yellow spots to the other.
4. Needle a purple stripe from one yellow spot to the other, on the opposite side to the turquoise stripe.
5. Needle a green stripe, also from one yellow spot to the other, between the turquoise stripe and the purple stripe.
6. Needle a pink stripe between the purple stripe and the turquoise stripes, on the opposite side to the green stripe.

Black and white ball with spots:

1. Make a white ball.
2. Needle black wool on to one half of the ball.
3. If necessary, add more white on to the border between the two halves to even it up.
4. Needle white spots on to the black half and black spots on to the white half.

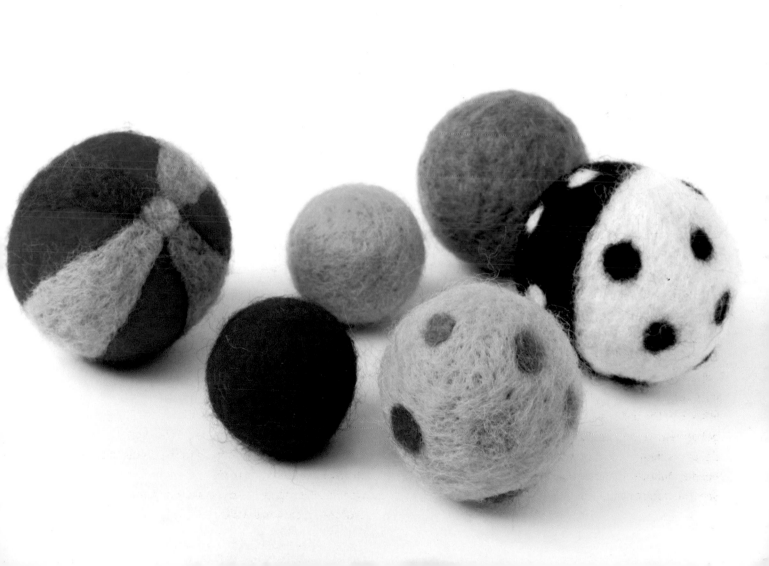

Pincushion made from remnants

Weight: 9g (0.3oz)
Height: 3.5cm (1½in)

What you will need:
· Wool of the desired colour(s)

Instructions:
Start in the same way as if you were making a ball, but instead of forming it into a round shape, needle a flat surface at the bottom. It has to be really firm. With regard to size, try sticking a pin into it. If it projects through the base, you will have to add more wool to make it bigger. Instead of making the pincushion from different coloured remnants, you can make it out of one colour and decorate it with various patterns in the same way as the ball.

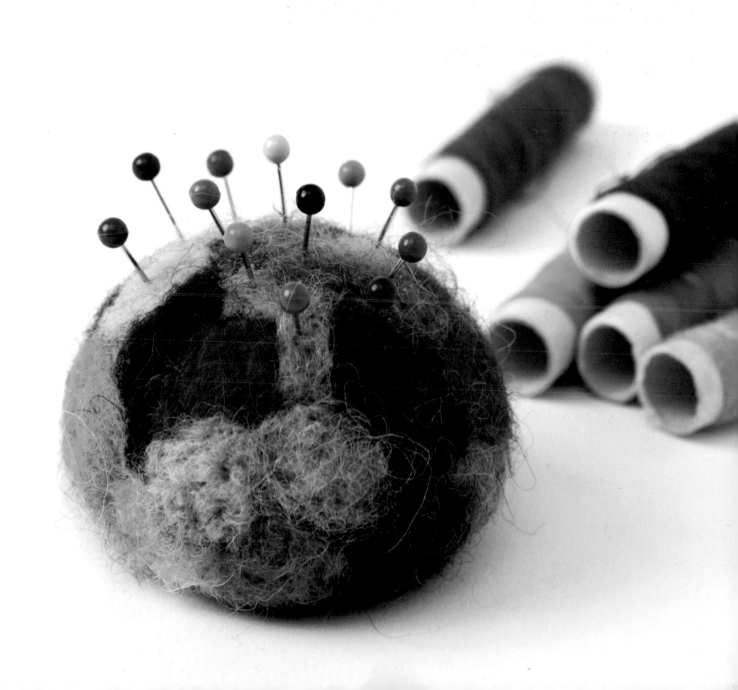

Fossilised sea urchin

Weight: 4–7g (0.14–0.24oz)
Height: 3–3.5cm (1¼–1½in)

What you will need:
- Grey or light brown wool
- White wool for the spots

Instructions:
Start in the same way as if you were making a ball, but needle a flat surface at the bottom. Needle into it so that it is slightly lopsided, with the top slightly off-centre. Needle it until it is really firm. (You might find it useful to look at some real fossilised sea urchins.)
Starting at the highest point on the sea urchin, attach rows of white spots running down the sides: ten rows in all, running in pairs. The top spots are the smallest. The stripes should preferably be incomplete, in other words with some of the spots missing.

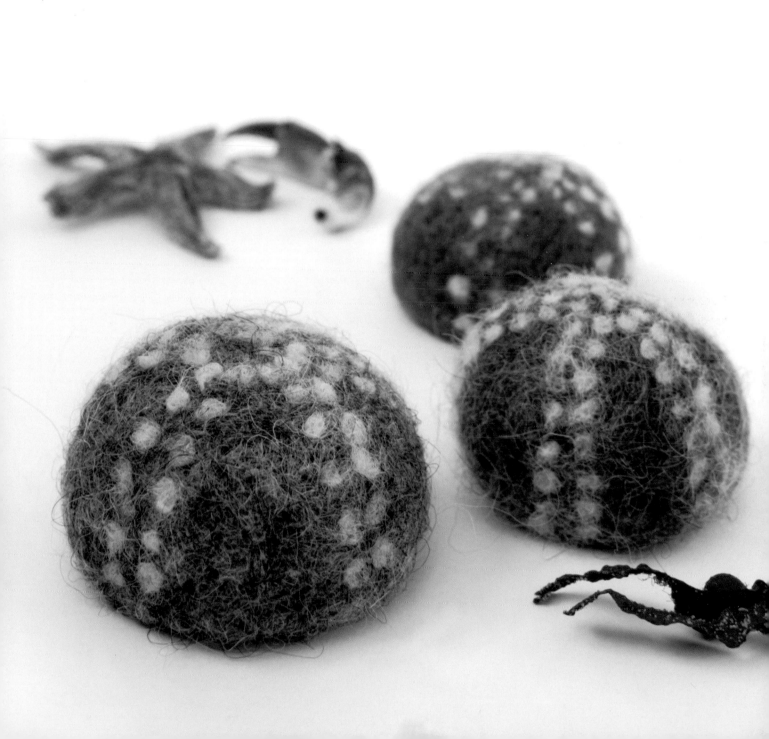

Dice

There are various ways of forming dice, in terms of size and colours, and also the way in which the spots are made – but the same procedure is used regardless. The dice have to be really firm. It is also important that they are angled properly, with flat surfaces and edges of the same length. This means that they are not as easy to make as you might think. Here are the instructions for the large die.

Weight: 5g (0.17oz)
Height: 3 x 3 x 3cm (1¼ x 1¼ x 1¼in)

What you will need:
- Black wool for the die
- Different colours for the spots

Instructions:
Take a clump of wool, spread out the fibres, then gather them together again so that they look like a proper mass. Needle into the clump from all sides. Once it is starting to firm up and take shape, you can start forming it into a die by needling flat surfaces on the six sides. Turn it regularly as you work. Look at it from all sides and check that it is uniformly firm. Apply wool anywhere where there are depressions.

Once the die has the correct firmness and shape, needle into the corners so that they become rounded. The edges should also be slightly rounded.

Finally, attach spots of the desired colour or colours.

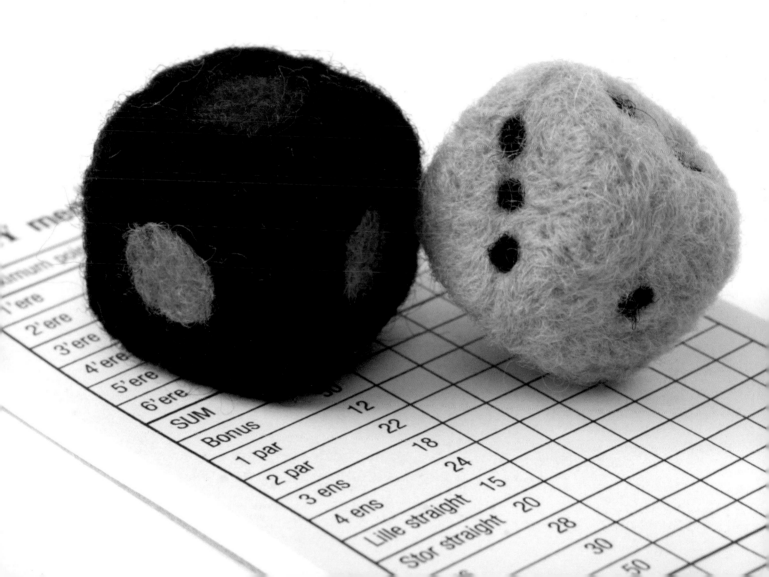

Placemat

Weight: 13–25g (0.45–0.88oz)
Diameter: Approx. 14–15cm (5½–6in)

What you will need:

- Wool of the desired colour(s)

The placemat needs to be needled so that it is really firm and it should be at least 1.5cm (½in) thick, as it will become flatter from use.

It can be just one colour or several colours – either with a particular pattern or motif or with the colours randomly mixed. For now, start with just one colour and wait until the placemat is the correct thickness and firmness before adding more colours – unless you want to play with colours as you go and are not bothered about creating a specific motif. The colours on one side change when you needle all the way through because the felting needle pushes wool fibres through from the other side. The wool fibres get mixed up and create new shades.

If you want to experiment, you could use this to obtain a new effect!

You should also note that if you needle into one surface for quite a long time, the placemat will eventually become stuck to the foam pad. Remember therefore to loosen the placemat from the foam pad every now and then.

Instructions:

1. Take a few loose clumps of wool and carefully place them across and next to each other in the desired shape. It does not matter if the edges are rough. Working from both sides, form the tufts into a flat 'pancake', and also needle into the edges.
 As well as feeling with your fingers to see if it is even, you can also hold it up to the light as you work to see if there are any 'gaps' where you need to do more needling.
2. Once the placemat is of the desired thickness and firmness, you can add new colours, applying a few small tufts at a time to create the desired pattern or motif, or just applying them randomly.

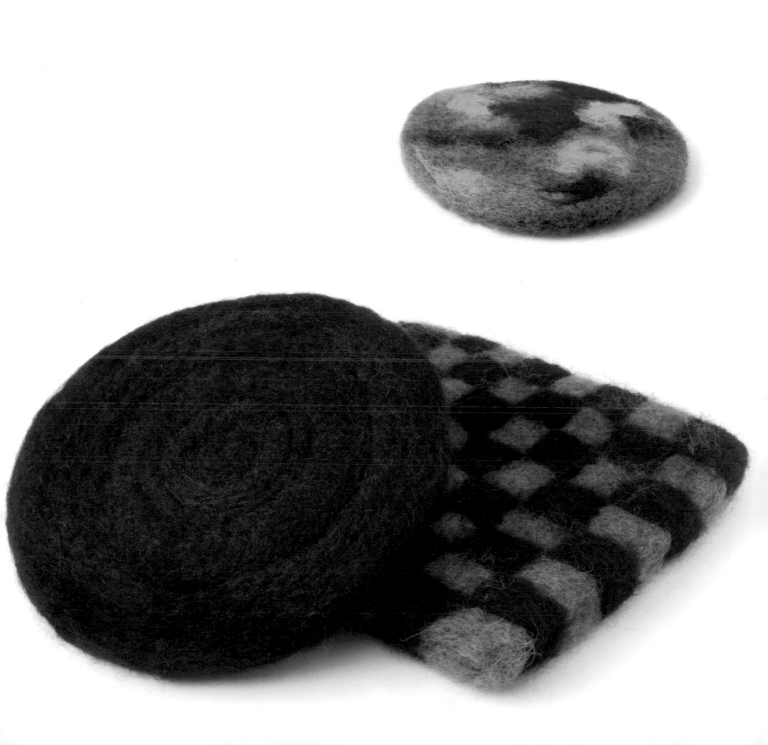

Flower brooch

What you will need:

- Wool in three different colours
- Brooch pin
- Glue or a needle and thread

Instructions:

1. Choose a base colour and make five small 'pancakes', leaving the wool loose on one side: see 'Ears' on page 12.
2. Arrange the pancakes in a circle so that the loose wool overlaps. Needle into the loose wool to join the pancakes together. Work from both sides.
3. Apply more layers until the flower is of the correct thickness and firmness – it must be firm.
4. Decide which side is to be the front and needle colour no. 2 into the centre of the flower.
5. Next needle the final colour into the centre of colour no. 2.
6. Attach the flower to the brooch pin using glue or a needle and thread.

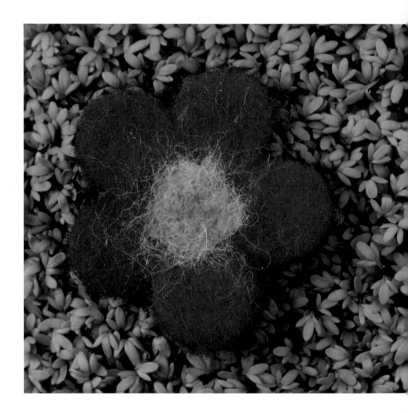

Butterfly brooch

What you will need:
- Red wool for the base colour
- Dark red wool for the body
- Yellow, black, white and blue wool for the spots
- Glue or a needle and thread
- Brooch pin

Instructions:

1. Make four small 'pancakes' out of red wool. They should be slightly oval and have loose wool at one end: see 'Ears' on page 12. They do not need to be quite so firm just yet.

2. Overlap the pancakes (one at each of the four points of the compass) so that the loose wool overlaps and they form a butterfly. Do not worry if the wings are a bit shapeless at this stage, as they will be corrected as you work. Needle into the loose wool so that the wings become joined together. Work from both sides, and apply more wool to ensure that the butterfly has a uniform thickness. Needle into the edges to form the wings. Once the butterfly has the right thickness, shape and firmness (and it has to be really firm) you can decorate it.

3. Decide which side is to be the 'front' and carry on working on this side. Needle dark red wool on to the butterfly's body to form a stripe down the middle.

4. Needle two yellow spots, one on each of the top wings. Needle a black dot into each of the yellow spots. Needle a white dot into the top of each of the yellow spots.

5. Needle two black spots, one on each of the bottom wings. Needle a blue spot into each of the black spots. Needle two small black dots above each of the black spots.

6. Attach the butterfly to a brooch pin using glue or a needle and thread.

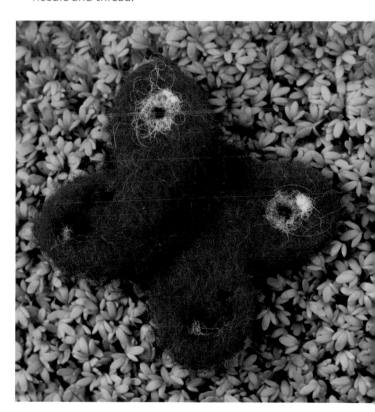

Caterpillars

Weight: 1–2g (0.03–0.07oz)
Length: Approx. 5–9cm (2–3½in)

What you will need:

- Green wool or some other colour for the body
- Various colours for spots and stripes

Instructions:

Make a sausage. It does not matter if it has a twist in it, as this will just make the caterpillar more life-like. Needle it to make it really firm and also needle all the way through if you want to, so that the caterpillar looks downy. Needle the bottom flat before it becomes too firm. Finally, needle on contrasting stripes or spots.

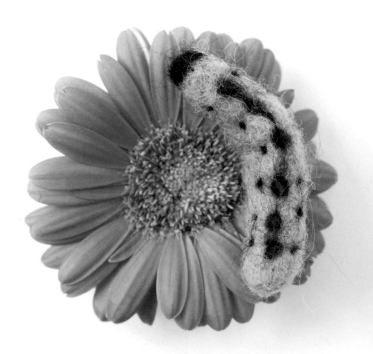

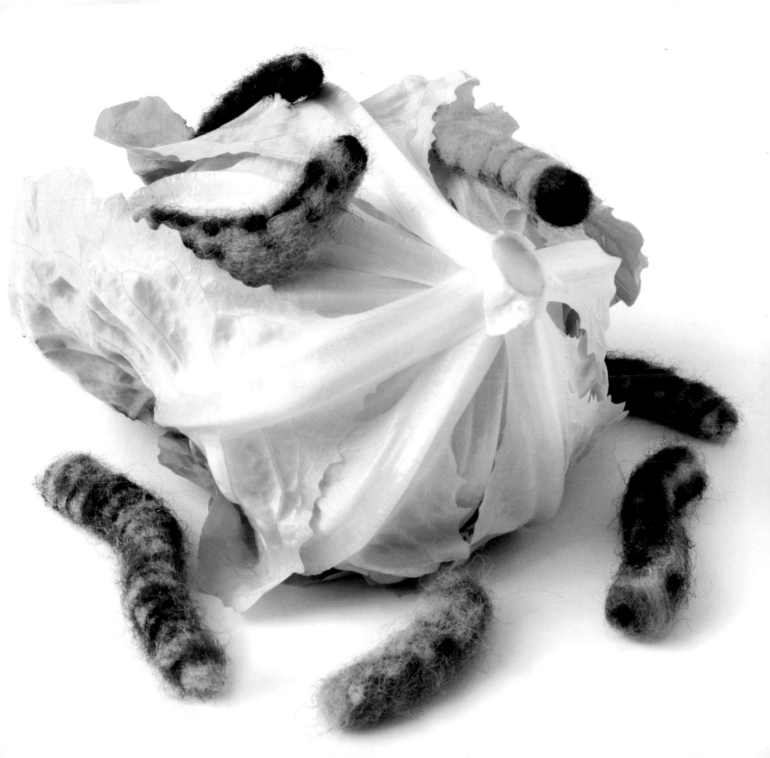

White mice

Weight: 3g (0.1oz)
Length (from snout to end of body): 5.5cm (2¼in)

What you will need:
- White wool for the body
- Pink wool for the snout
- Red wool for the eyes

Instructions:

1. For the body: Make a small sausage out of white wool, thick at one end and thinning to a point at the other. Needle a flat surface at the bottom.
2. The tip of the snout: Needle a small ball out of the pink wool and attach it to the snout.
3. Ears: Take two tufts of white wool and needle them flat to form ears: see 'Ears' on page 12. Place the ears on the side of the head and attach them.
4. Eyes: Take two small tufts of red wool and use these to make two dots where the eyes are to be.
5. Tail: Make a thin sausage about 9–10cm (3½–4in) long. Only needle the tip of the tail a little and do not needle the wool fibres in. Leave 1–2cm (½–¾in) of loose wool at the other end. Moisten your hands and roll the tail between them to get all the loose fibres that are sticking up to lie flat. Finally, attach the tail to the body.

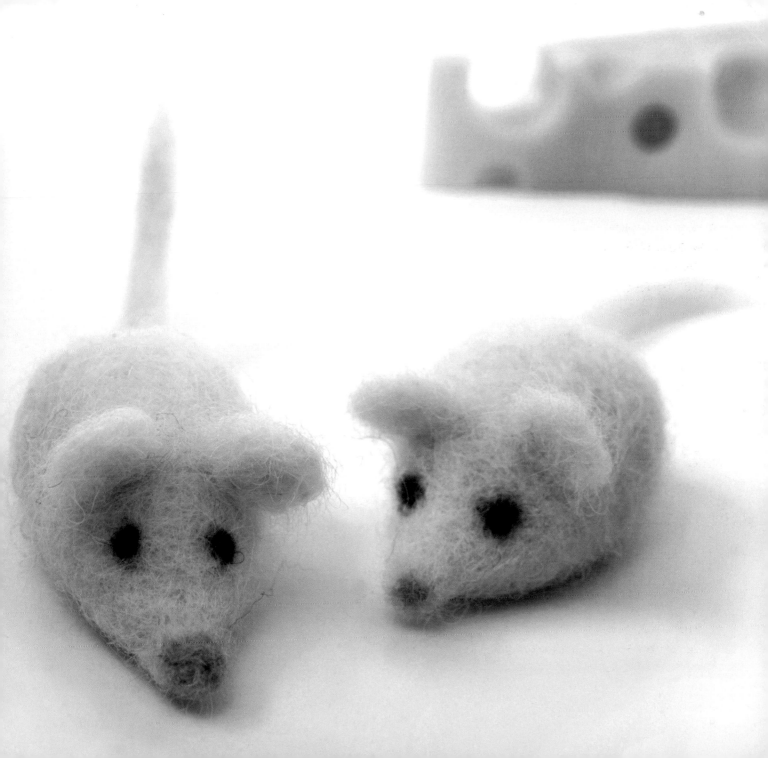

Snowman

Weight: 5g (0.17oz)
Height: 7cm (2¾in)

What you will need:

- White wool for the body
- Black wool for the hat, eyes and buttons
- Orange wool for the nose

Instructions:

1. Make a sausage using the white wool, measuring 4–5cm (1½–2in) in length.
2. Head: Apply several layers all the way around the top 1–2cm (½–¾in) of the sausage.
3. Body: Apply several layers all the way around the bottom 2–3cm (approx. 1in) of the sausage. Needle a flat surface at the bottom so that the snowman does not topple over.
4. Nose: Make a carrot of the required size. Leave the wool loose for about the last 0.5cm (¼in) at the thick end.
5. Attaching the nose: Fold the loose wool in. Place the carrot on the snowman's face and attach it by needling in through the carrot and down into the face, working all the way round.
6. Eyes: Take two small dots of black wool and needle them into place.
7. Buttons: Take three small dots of black wool and needle them on to the front of the snowman.
8. Hat: The brim: Make a flat pancake out of black wool. Do not needle it too firmly in the centre, but needle into the edge all the way around.
 The crown: Make a short, thick sausage out of black wool. Needle it flat at one end, leaving the wool loose at the other end. Spread the loose wool out to the sides. Place the crown on to the brim and attach it by needling all the way round.
9. Attaching the hat: Take a small tuft of black wool (this is used to fasten the hat in place). Place this tuft on the bottom of the hat and needle into it a few times. Place the hat on the snowman's head and attach it by needling down at an angle through the hat and into the head, working all the way round.

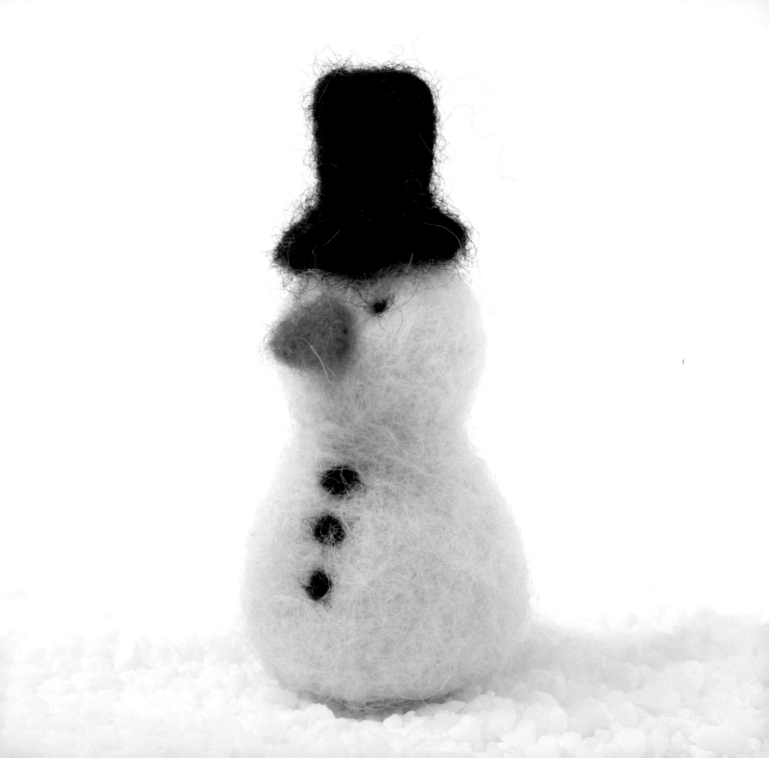

Penguin

Weight: 1–3g (0.03–0.1oz)
Height: 5cm (2in)

What you will need:

- White wool for the body
- Black wool for the body and eyes
- Orange wool for the beak

Instructions:

1. Make a thick sausage measuring about 5cm (2in) in length. The bottom part must be slightly thicker. Close the sausage at both ends and needle a flat surface into the bottom.

2. Apply black wool from the head, down the sides and the back, and tapering to a point on the forehead.

3. Arms: Take two tufts of black wool and form them into two flat, elongated arms, working from both sides. Needle into the edges, but remember to leave loose wool at one end for attaching them to the body.

4. Attaching the arms: Place the arms on the body and attach them by needling into the loose wool.

5. Beak: Make a small 'carrot' out of orange wool. Leave the final 0.5cm (¼in) at the thick end loose.

6. Attaching the beak: Place the beak on to the penguin's face and use the needle carefully to push the loose wool in. Attach the beak by needling diagonally in through it and down into the face, working all the way round.

7. Eyes: Take two very small tufts of black wool and needle them into small dots for the eyes.

8. Tail: Make a small triangle out of black wool and attach it to the bottom of the back.

9. Adjust the base, applying more wool if required, so that the penguin stands up properly.

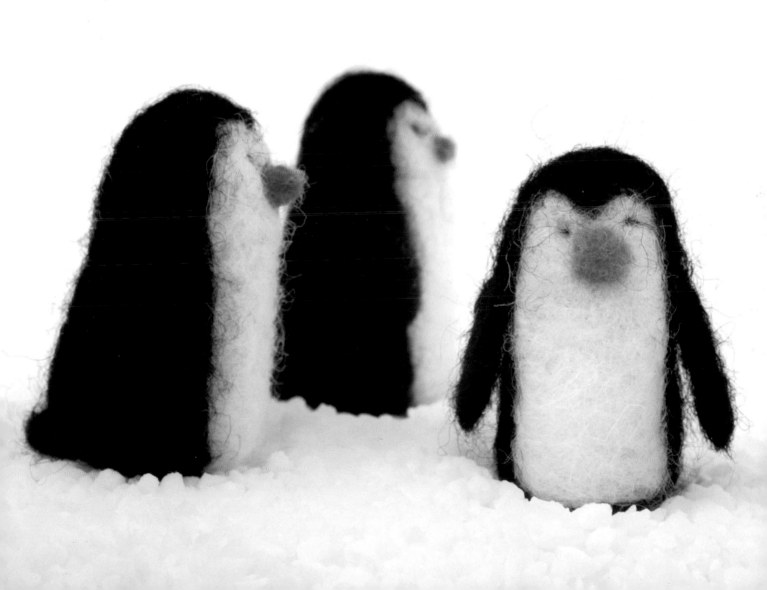

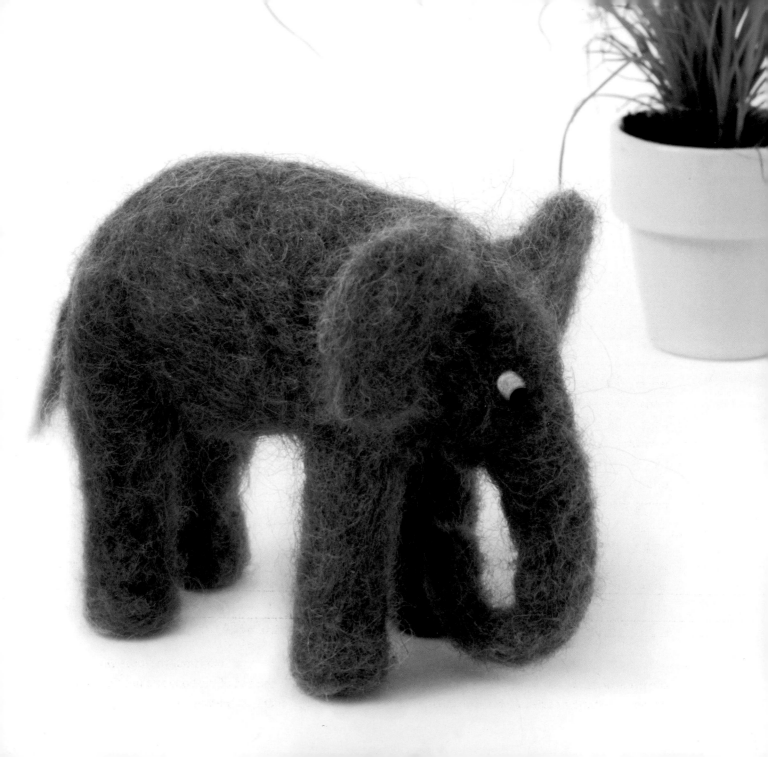

Elephant

Weight: 10g (0.35oz)
Length (from head to the end of the body): 7cm (2¾in)

What you will need:
- Grey wool for the body
- White wool for the eyes
- Black wool for the eyes

Instructions:

1. Make a thick sausage measuring about 6cm (2¼in) in length, with most of the wool at one end to produce a shape like an elongated pear. This is the elephant's body and head.
2. Legs: Make four sausages the right size for the body. Make them flat at one end and leave the wool at the other end loose. The top half of the back legs should be slightly thicker.
3. Attaching the legs: First attach the back legs: see 'Legs' on page 13. Next, attach the front legs but make sure you do not attach them too far forward, as the end of the 'pear' is going to be the elephant's head.
4. Trunk: Make a long sausage about 7–8cm (approx. 3in) in length. Close it at one end and leave the other, slightly thicker end, loose. Do not make it too firm.
5. Attaching the trunk: Spread out the loose wool. Place the trunk on to the head and needle it into place. At the same time, needle into the trunk to make it firmer while you choose its direction. Should it be pointing up or down, or should it bend in towards the legs? See 'Arms' on page 14. If necessary, apply more wool to adjust the shape.
6. Ears: Make two big ears. They need to be almost triangular. Needle into the edges on two sides, but leave the wool loose on the third side.
7. Attaching the ears: Place the ears on the head and needle them into place.
8. Eyes: First needle two eyes out of white wool and then a black dot in each of the two whites.
9. Lower jaw: Make a small 'pancake' that is the right size for the elephant and shaped like a half moon. Needle into the straight edge, but leave the wool loose on the curved edge.
10. Attaching the lower jaw: Place the lower jaw underneath the head where the trunk begins. The loose wool should point back towards the legs, and the mouth should be slightly open – in other words the lower jaw should not be rigid. Needle the lower jaw into place.
11. Tail: Make a thin sausage, leaving the ends open. It must be slightly thicker at the end that is to be attached to the body.
12. Attaching the tail: Spread out the loose wool, place the tail at the end of the body and needle it into place, working all the way round.

Long-necked dinosaur

Weight: 12g (0.42oz)
Length (from head to tail): 27cm (10¾in)

What you will need:
- Greyish wool for the body
- Black wool for the eyes

Instructions:
1. Make a long, thin sausage measuring about 27cm (10¾in) in length. Needle in at the end where the head is going to be so that it is rounded. At the other end, the tail needs to be thinner and taper to a point, so do not needle into that end.
2. Body: Attach several layers on to the middle 6–8cm (2¼–3¼in) of the sausage. You will need a lot of layers! Make sure that these extra layers blend smoothly into the neck and tail. Decide which side is going to be the top and which is going to be the underside. Needle into the bottom side of the tail where it meets the body so that it points down. In the same way, needle into the top of the neck to lift the head up.
3. Legs: Make four legs of an appropriate size for the body. Make them flat at one end and leave loose wool at the other end.
4. Attaching the legs: Attach two legs first (see page 13), and then the other two. Apply more layers to create a smooth join, to strengthen the join and to further define the shape. Look at the figure as you work to check that the legs are on right and that the dinosaur sits on all four legs.
5. Head: Needle into the snout to make it flatter. Loosely form a small pad, place it on the head and needle it into place to form a small forehead.
6. Eyes: Needle two small dots out of black wool just in front of the forehead.
7. Lower jaw: Make an elongated pancake that is the same width as the snout. Needle into both surfaces and around the edge, except for one end which is left loose.
8. Attaching the jaw: Place the lower jaw beneath the head with the loose wool pointing towards the body. Needle it into place so that the dinosaur's mouth is slightly open.
9. Finally, you can get the tail to swing to one side by bending it slightly and needling into the inside of the bend.

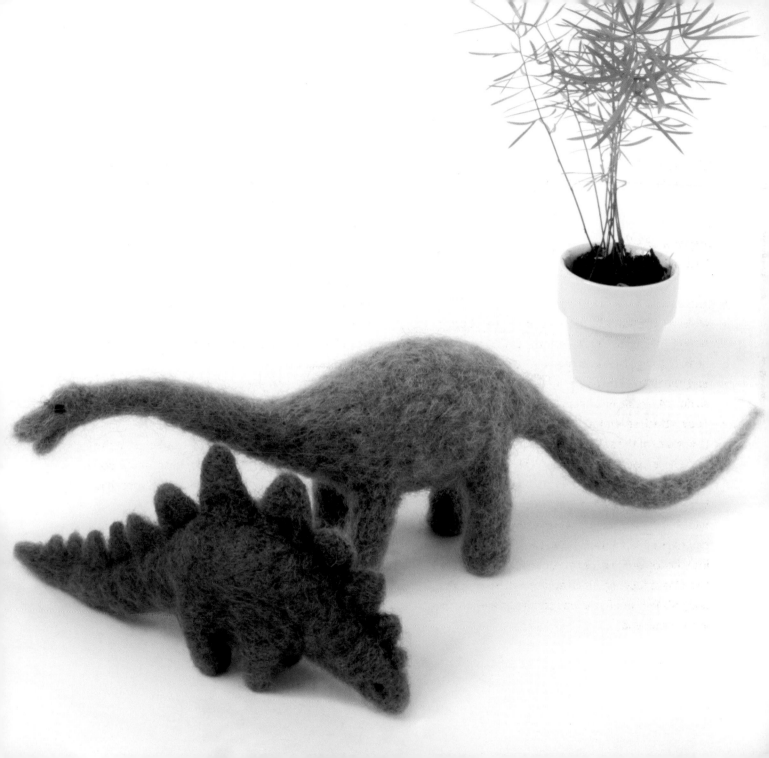

Stegosaurus

Weight: 8g (0.28oz)
Length (from head to tail): 15cm (6in)

What you will need:
- Greenish wool for the body
- Black wool for the eyes

Instructions:
1. Make a long, thin sausage measuring about 15cm (6in) in length. It should be closed and tapered at both ends.
2. Body: Decide which end is going to be the head, and which side is going to be the top and which the underside. Apply a number of layers on to the front 8–10cm (3¼–4in), on the back and the side, but mostly on the back. The transition to the head and the tail must be smooth.
3. Legs: Make four short sausages. Make them flat at one end and leave loose wool at the other end.
4. Attaching the legs: First attach two legs (see page 13), then attach the other two. Check that the animal rests on all four legs. Needle into the underside, where the tail starts, to make it point downwards. Do the same where the head starts to make it point down too.
5. Back plates: Make a number of plates (about 12) to go along the back. They need to be triangular, but of varying sizes. The biggest should be placed at the top of the back, getting gradually smaller as they go down to the head and the tail. Needle into them on both sides. They should be flat but not too thin. Needle into two of the edges, but leave loose wool at the third edge.
6. Attaching the plates: Start with the biggest plate. Spread out the wool and place it at the top of the back. Needle all the way round the plate and also diagonally in through the plate into the back. Attach the rest of the plates in the same way. The smallest plates should be at the head and tail ends.
7. Eyes: Take two quite small tufts of black wool and form them into two eyes. Since the stegosaurus has a very small head compared with its body, they should be placed really close to the snout.
8. Mouth: If you want to, needle a small groove to mark the mouth.

Ladybird

Weight: 1g (0.03oz)
Length: 3.5cm (1½in)

What you will need:
- Red wool for the body
- Black wool for the head and the spots

Instructions:
1. Take a clump of red wool and start as if you were making a ball, but needling it flat at the bottom. Also, it should ideally be slightly elongated.
2. Apply black wool to one end for the head.
3. Needle a small groove along the middle of the back.
4. Take seven small tufts of wool for the spots and needle them into the positions, as shown in the drawing. To obtain sharply defined edges around the head and the spots, carefully push the fibres into place using the needle. See 'Edges and ...' on page 10.

Baby in swaddling clothes with bonnet

Weight: 3g (0.1oz)
Length: 6cm (2¼in)

What you will need:

- Skin-coloured wool for the head and 'body'
- White wool for the swaddling clothes
- Blue wool for the eyes
- Pink or pale blue wool for the bonnet

Instructions

1. Make a thick sausage out of skin-coloured wool, 5–6cm (2–2¼in) long. It must be closed at both ends.
2. If required, mark the neck about 2cm (¾in) down by needling all the way round.
3. Nose: Loosely needle a small ball and attach it to the centre of the face.
4. Eyes: Take two quite small tufts of blue wool – in fact just a few fibres – and form them into two small dots where the eyes will be. See 'Edges and ...' on page 10.
5. Body: Apply several layers of white wool on to the body from the neck downwards. Needle into it and close it at the foot end. Needle it flat on the back so that the baby does not roll.
6. Bonnet: Apply a layer of pink or pale blue wool to the head, making sure it is not too tight, and needle it into place in the required shape of the cap. Also apply a thin strip of the same colour around and underneath the chin.

Baby wrapped in blanket

Weight: 3g (0.1oz)
Length: 8cm (3¼in)

What you will need:
- Skin-coloured wool for the head and 'body'
- White wool for the swaddling clothes and blanket
- Blue wool for the eyes
- Brown wool for the hair

Instructions:
Follow steps 1–5 for 'Baby in swaddling clothes with bonnet'.

6. Hair: Take a small tuft of brown wool and needle it into place on the baby's head.
7. Blanket: Loosely form a soft blanket – making sure it is neither too thick nor too rigid. In fact, it should really only just about hang together. It must be big enough to be wrapped around the baby without being tight. Only needle the edge at the top – it does not really matter whether or not the shape and the top edge are perfectly straight.
8. Place the baby on the blanket and wrap the blanket around the baby and up around its head. Make sure the blanket is not tight. Attach it by needling into it as little as possible. Also needle into the back a little.

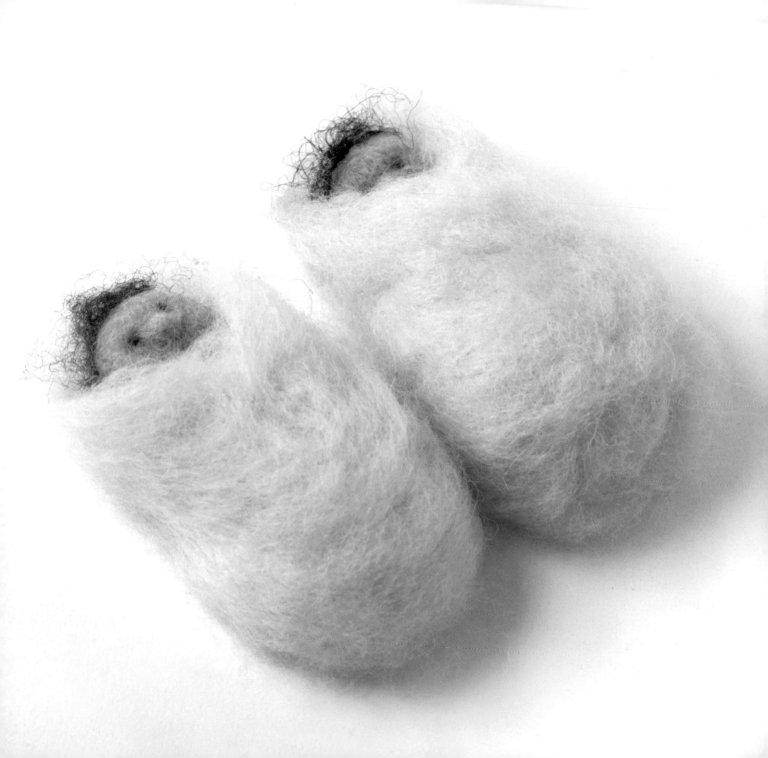

Hare

Weight: 1–4g (0.03–0.14oz)
Height: 7–9cm (2¾–3½in)

What you will need:
- Light brown wool for the body
- White wool for the eyes
- Black wool for the eyes and the snout

Instructions:

1. The body: Make a small sausage 6–7cm (2¼–2¾in) long. It must be thicker at the bottom than at the top. Needle a flat surface at the bottom and add a little extra wool on to the tummy.

2. Cheeks: Make a small sausage. It must be a little longer than the width of the head. Needle it quite lightly (it is not firmed up until it has been attached to the face) and leave the wool loose at the ends. Place it horizontally on to the face 1.5–2cm (½–¾in) down, and needle it into place. Needle into the loose wool and through the sausage. Add more wool if the cheeks need to be fuller or to even out any irregularities.

3. Nose: Take a small tuft of black wool and form it into a triangle in the middle of the face, with the tip pointing down. Needle a groove from the tip of the triangle down a few mm, and then branch out to either side to mark the mouth.

4. Ears: Make two long ears. Also needle into the edges, but remember to leave loose wool at one end for attaching them.

5. Attaching the ears: Place the ears far enough towards the back of the head to be flush with the back of the head. Needle them into place.

6. Eyes: First make two eyes from white wool, and then a black dot in each of these whites.

7. Arms: Make two small sausages of the right size for the hare, leaving loose wool at one end.

8. Attaching the arms: Place the arms on the shoulders. Spread the loose wool out behind the shoulders so that the arms are turned slightly forward, then needle them into place.

9. Feet: Make two elongated feet out of brown wool. Measure them against the bottom of the hare to see how big they will be (they should project by 1.5–2cm (½–¾in) in front).

10. Attaching the feet: Add a small tuft of light brown wool to each foot and loosely needle it into place. Place the body on top and needle the feet into place from below.

11. Tail: Make a small round tail, leaving some loose wool to attach it by. Attach the tail by bending the loose wool in under the feet and needling it into place. Add more wool if required in order to make the hare stable.

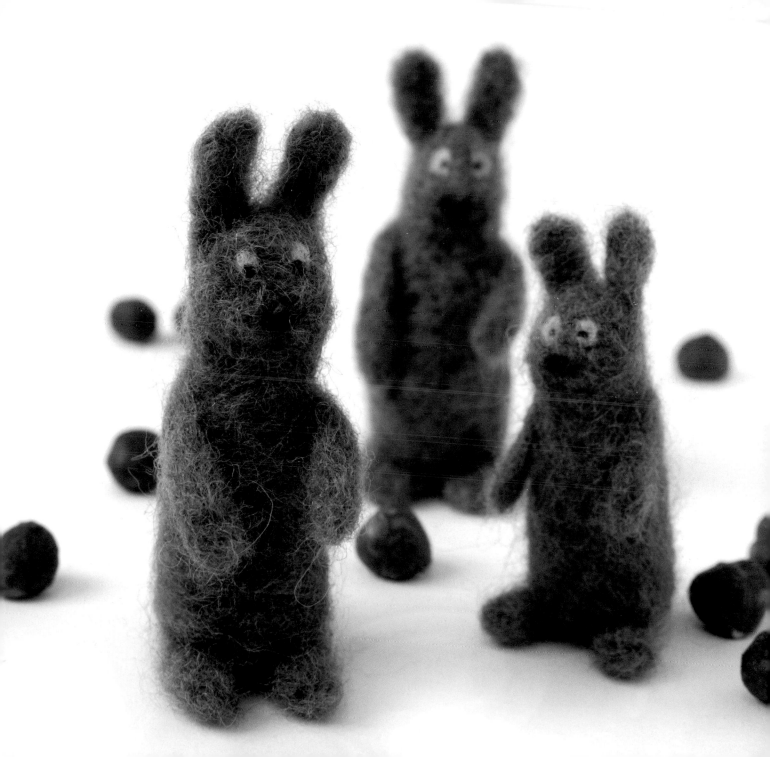

Three small mice

The procedure is the same for all three mice, but just using different colours. These instructions are for the grey mouse.

Weight: Approx. 2g (0.07oz)
Height (from ears to bottom): 6cm (2¼in)

What you will need:
- Grey wool for the body
- White wool for the eyes
- Black wool for the eyes
- Pink wool for the snout

Instructions:
1. Make a thick sausage 4cm (1½in) long. It must be closed at both ends.
2. Head: Apply an extra layer all the way round the top third of the sausage.
3. Body: Apply extra layers all the way round on to the rest of the sausage. Needle it flat at the bottom. Make sure that the neck is marked out by needling all the way around.
4. Snout: Make a small sausage, tapering to a point at one end and leaving 1–2cm (½–¾in) of loose wool at the other end.
5. Attaching the snout: Spread the loose wool out to either side. Place the snout on to the face so that the wool goes over the cheeks (it must not be tight). Attach the snout by needling in the loose wool and needling diagonally in through the snout: see page 11. If you want to mark out the mouth, needle a hole or a groove beneath the snout.
6. Cheeks: Add more wool to the cheeks if you want to fill them out a bit more.
7. Tip of the snout: Make a small pink ball and attach it to the snout. Also needle in through the tip of the snout.
8. Eyes: First make two eyes out of white wool, then needle a black dot in each of the whites.
9. Ears: Make two round ears of the right size for the mouse. Also needle into the edge, but make sure you leave some loose wool for attaching them.
10. Attaching the ears: Place the ears on the head, then needle them into place.
11. Arms: Make two thin sausages, 3–4cm (approx. 1½in) long. They should have loose wool at one end and be closed at the other end.
12. Attaching the arms: Place the arms on the body. Spread the loose wool behind the shoulders and needle it into place.
13. Legs: Make two thin sausages about 5cm (2in) long plus the loose wool. They should be closed at the foot end. The foot should be about 2cm (¾in) long. 'Bend' the leg at that point and needle into the heel so that it keeps its shape.

14. Attaching the legs: Place the legs so that the mouse is sitting on the loose wool and the tops of the legs, then needle them into place.

15. Tail: Make a long thin sausage, leaving loose wool at one end. The other end tapers to a point; in other words it should be needled, but without needling into the end. Finally, moisten your hands and roll the tail between them to get all the loose fibres that are sticking up to lie flat. If you want the tail to have any bends in it, just needle a few times into where you want the bends to be.

16. Attaching the tail: Spread out the loose wool. Place the tail beneath the mouse's bottom and needle it into place.

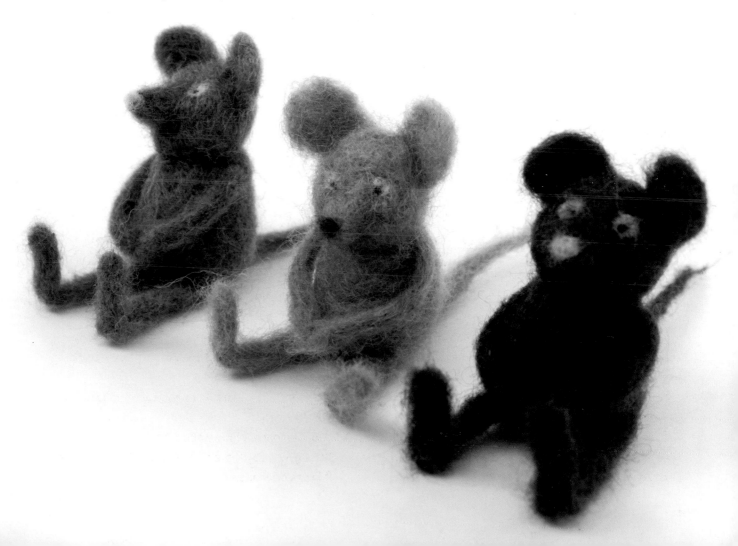

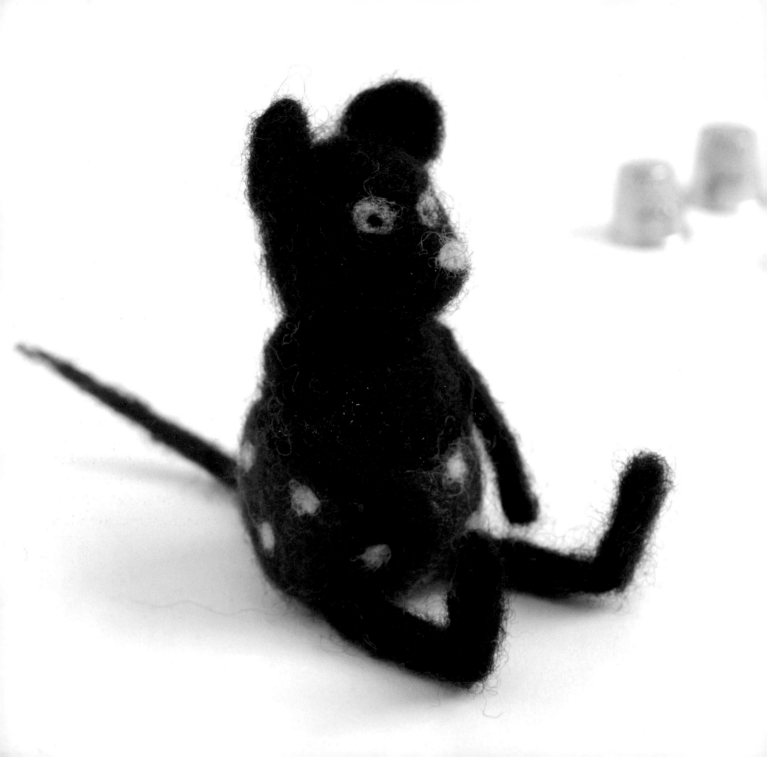

Mouse with pants

Weight: 4g (0.14oz)
Height (from ears to bottom): 7½cm (3in)

What you will need:
- Black wool for the body
- Red wool for the pants
- White wool for the eyes and spots
- Pink wool for the snout

Instructions

1. Make a sausage out of black wool, about 5cm (2in) long. Close both ends.

Follow steps 2–10 for 'Three small mice'.

11. Pants: Apply red wool, a bit at a time, all the way round the bottom half of the body. Next apply white wool spots, except on the bottom.

12. Legs: Make two thin sausages, 5–6cm (2–2¼in) long. They should be closed at one end and have loose wool at the other end. The feet should be about 2cm (¾in) long. 'Bend' the leg there and needle into the heel a few times so that it keeps its shape.

13. Attach the legs: Place the legs underneath the bottom and needle them into place.

14. Arms: Make two thin sausages, 4–5cm (1½–2in) long. They should be closed at one end and have loose wool at the other end.

15. Attaching the arms: Place the arms on the body with the loose wool spread out behind the shoulders, and needle them into place.

16. Tail: Make a tail, 8–10cm (3¼–4in) long: see 'Three small mice'.

17. Attaching the tail: Place the tail underneath the mouse's bottom and needle it into place. Apply more red wool to cover up the join where the legs and tail are attached, see page 55. At the same time add wool to the mouse's bottom if required in order for it to sit up properly, though the bottom should still be flat. Finally, apply some small white dots on to the bottom if required.

Troll

Weight: 6g (0.21oz)
Height: 10.5cm (4in)

What you will need:
- Grey wool for the body
- White wool for the eyes
- Black wool for the eyes

Instructions:

1. Make a sausage, about 8–9cm (3¼–3½in) long. It should be closed at both ends.
2. Head: Apply several layers all the way round the top third of the sausage.
3. Body: Apply several layers all the way round the bottom two-thirds. Mark out the neck as you work by needling all the way around it.
4. Nose: Make a small sausage the right size and shape for the troll's nose. It should be closed at one end, with loose wool at the other.
5. Attaching the nose: Spread the loose wool out, place the nose on the troll's face and needle it into place all the way round, also needling diagonally in through the nose.
6. Forehead: If required, apply more wool on to the forehead to make the troll look slightly angry.
7. Eyes: Make two eyes out of white wool, and then add a dot made from black wool to each of the whites.
8. Mouth: If you want, you can mark a mouth by needling a groove where you want it to be.
9. Ears: Make two ears that are the right size and shape for the troll. Place them on the troll's head and needle them into place.
10. Legs: Make two legs and attach them as described on page 13.

11. Arms: Make two arms as described on page 14. If the arms are going to be hanging at the troll's sides, put a 'bend' in them at the elbows before they become too firm, and needle in at the elbows so that they keep their shape.

12. Attaching the arms: Place the arms on the shoulders and needle them into place as described on page 14. If the troll's hands are going to be hanging at his sides, fasten them in place using small tufts of wool: take a small tuft of wool, place it on the side of the hand facing into the body and needle it in place from the outside.

13. Tail: Make a thin sausage that is the right thickness for the troll, 7–8cm (approx. 3in) long. Do not needle into it at the ends. It should also be a bit thicker at the end that is to be attached to the body. It should be made as firm as the rest of the body, since it also helps to prop the troll up.

14. Attaching the tail: Spread out the wool, place the tail on the troll's bottom and needle it into place all the way round. Also, needle diagonally in through the tail and into the troll's bottom.

15. Hair: Take a few small tufts of grey wool, place them on the head and needle them quite loosely into place so that they still stick up.

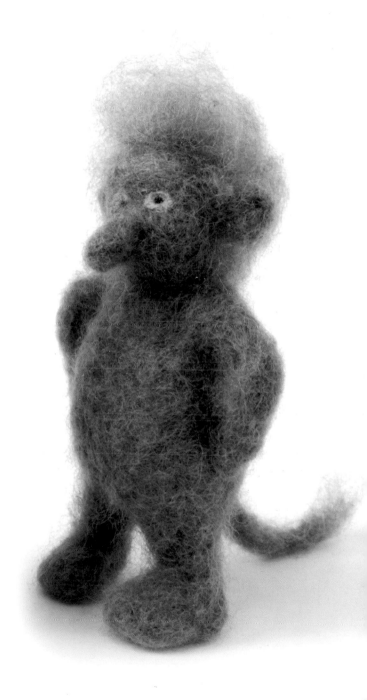

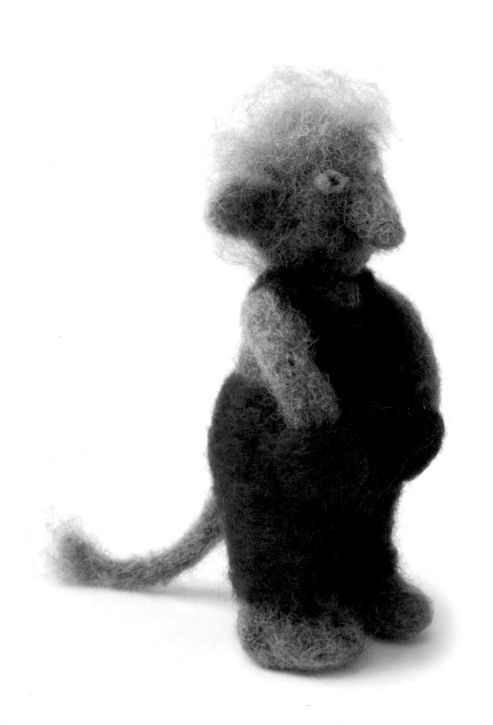

Troll with clothes

Weight: 9g (0.31oz)
Height: 10.5cm (4in)

What you will need:
- Grey wool for the body
- Red wool for the clothes
- White wool for the eyes
- Black wool for the eyes and buttons

Instructions:
Follow steps 1–10 for 'Troll'.

11. Clothes: Apply red wool where the clothes are supposed to be – though not the braces or pockets. Do not use too much wool at a time and do not pull it tight.
12. Arms: Make two arms and attach them as described on page 14. The arms should hang down in front and sit close in to the body.
13. Pockets: Apply red wool over the troll's hands to create two pockets. Be careful not to tighten the wool when applying it and needling it into place.
14. Braces: Apply braces from the waist at the back of the pants and up over the shoulders to the bib on the front. Apply two black wool dots for the buttons.
15. Tail: Make a tail as described in point 13 under 'Troll'.
16. Attaching the tail: Spread the wool out, place the tail on the troll's bottom, and needle it firmly into place. Apply red wool around the tail to cover the join so that it looks as if the tail is sticking out through a hole in the back of the pants.
17. Hair: As in point 15 under 'Troll'.

The troll's tail

Little bear (without clothes)

Weight: 3–7g (0.1–0.24oz)
Height (standing): 5–9cm (2–3½in)

What you will need:

- Brown wool for the body
- White wool for the eyes
- Black wool for the eyes and the tip of the snout

Instructions:

1. Make a sausage out of brown wool, about 6cm (2¼in) long and closed at both ends.
2. Head: Apply several layers all the way round the top third of the sausage.
3. Body: Apply several layers all the way round the bottom two-thirds. Mark out the neck as you work by needling all the way around it.
4. Snout: Make a short sausage (or more accurately the 'end' of a sausage). It should be closed at one end, with loose wool at the other end.
5. Attaching the snout: Spread out the wool, place the snout on to the bear's face, and needle it into place: see page 11. Add more wool to the cheeks if required.
6. Tip of the snout: Make a small ball of black wool and needle it into place on the end of the snout.
7. Mouth: If you want to mark where the mouth is, you can do this as described under 'Mouths' on page 12.
8. Eyes: Make two eyes out of white wool, and then a black wool dot in each of the two whites.
9. Ears: Make two small round ears of the right size and attach them to the head: see 'Ears' on page 12.
10. Legs: Make two legs and attach them to the body as described on page 13. If the little bear is going to be sitting down, then needle a flat base into its bottom.
11. Arms: Make two arms and attach them to the body as described on page 14.

If you want the little bear to stand up, you will need to adjust its balance as you work on it.

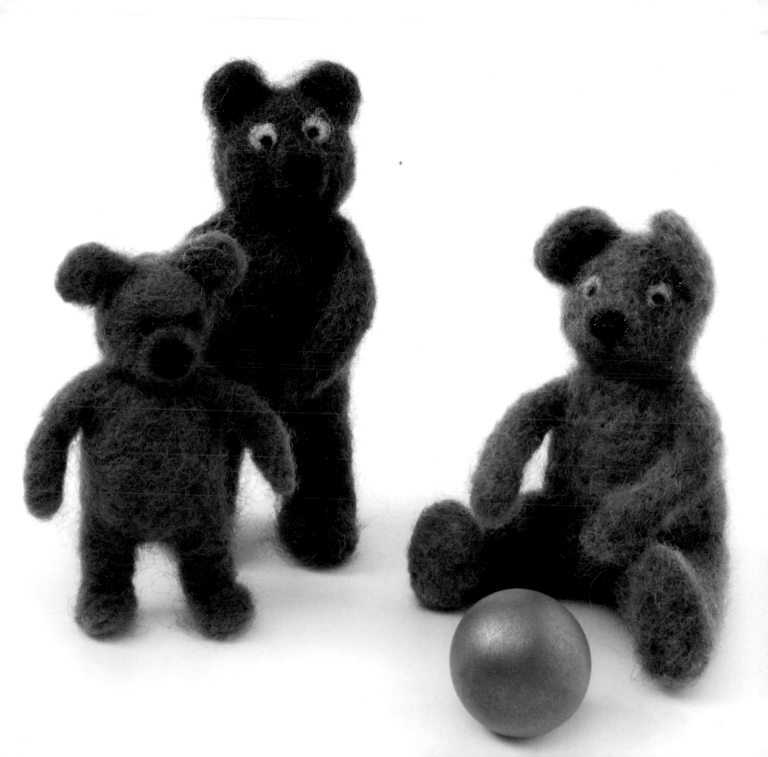

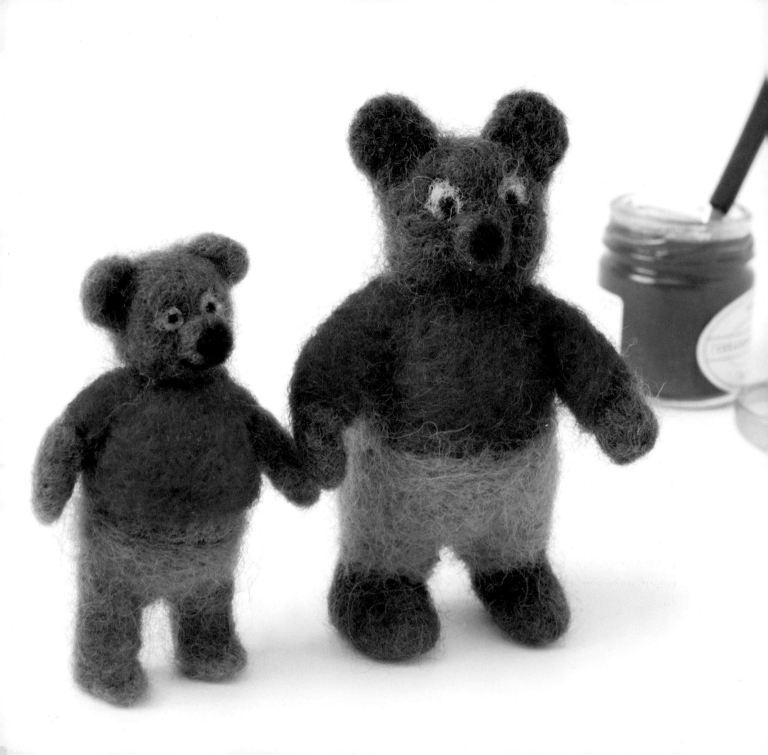

Little bear (with clothes)

Weight: 4 and 9g (0.14 and 0.31oz)
Height: 7.5 and 9.5cm (3 and 3¾in)

What you will need:
- Brown wool for the body
- Blue wool for the pants
- Red wool for the shirt
- White wool for the eyes
- Black wool for the eyes and the tip of the snout

Instructions:
Follow steps 1–11 for 'Little bear (without clothes)'.

12. Pants: Apply blue wool to where the pants are supposed to be. Avoid using too much wool at a time, and make sure the tufts are not tight when you apply them.
13. Shirt: Apply red wool where the shirt is to be. Avoid using too much wool at a time, and make sure it is not tight when you apply it. If the little bear is going to have long sleeves, it is easier to apply wool in the colour of the shirt to the arms before attaching them to the body.

Martians

These martians are all made in the same way, with the only differences being size, colour and a few details. Their distinguishing feature is their long necks. Remember to adjust the balance as you work.

Weight: 4–7g (0.14–0.24oz)
Height: 10–12cm (4–4¾in)

What you will need:
- Wool in various colours

Instructions:
1. Make a sausage, 6–7cm (2¼–2¾in) long and closed at both ends.
2. Head: Apply several layers all the way round the top 1–2cm (½–¾in).
3. Body: Apply several layers all the way round the bottom 3–4cm (approx. 1½in). There should be a gap of 1.5–2cm (approx. ¾in) between the head and the body, giving the martian his long neck.
4. Legs: Make two legs and attach them as described on page 13. The feet should be relatively big.
5. Arms: Make two arms and attach them as described on page 14.
6. Nose: Make a nose that you think is the right shape and size for the martian, and attach it as described on page 11.
7. Mouth: Form the mouth as described on page 12 – or you can make a mouth with a tongue: Needle a mouth out of pink wool on to the face. Make a tongue out of red wool, leaving as little loose wool at one end as you can, though enough for attaching it. Place the tongue on to the mouth, carefully fold the loose wool in using the felting needle, and needle it into place.
8. Eyes: Make some eyes as described on page 11. Or you can make red bulging eyes like those of the green martian: Make two balls of red wool that are not too firm and needle them into place on the face. Needle a black dot in the centre of each of these red eyes.
9. Ears: Make two ears that you think are the right shape and size for the martian, and needle them into place.

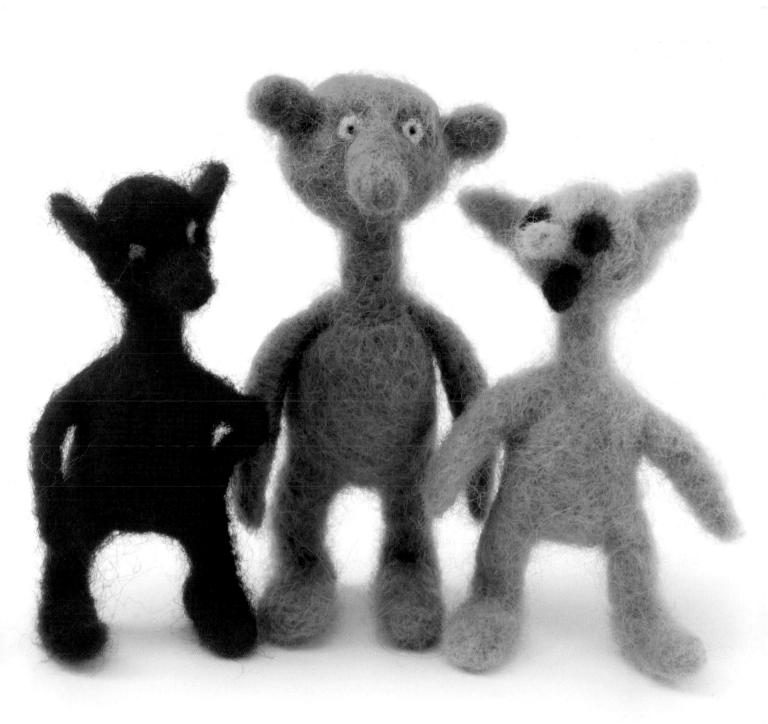

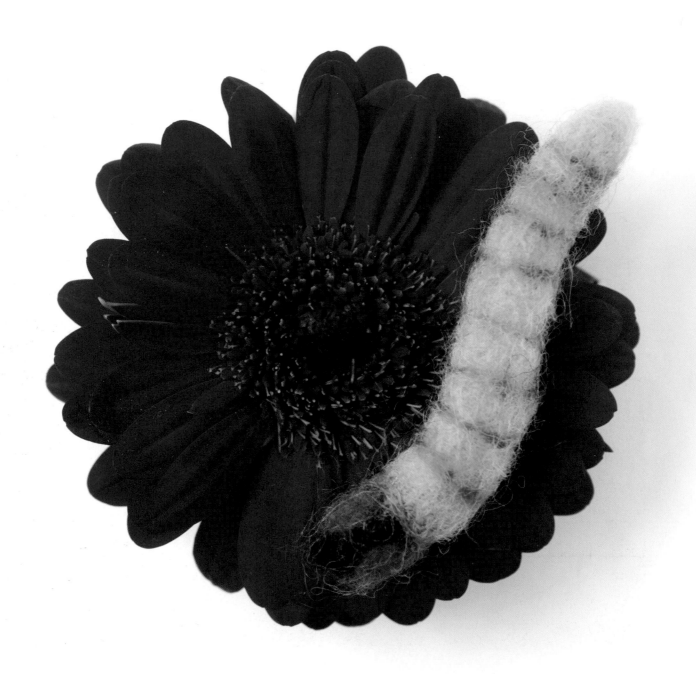

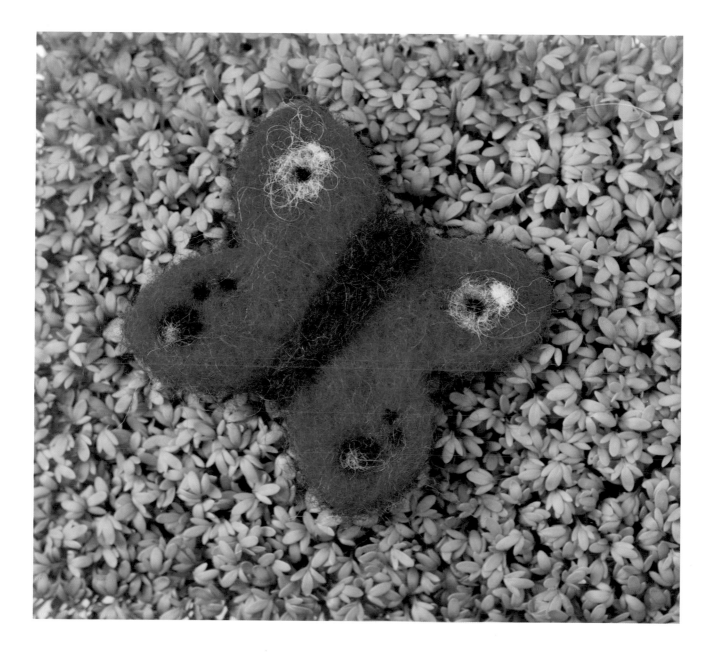

First published in Great Britain 2009 by Search Press Limited,
Wellwood, North Farm Road, Tunbridge Wells, Kent TN2 3DR

Originally published as *Sjove Figurer i Nålefilt* in Denmark
2007 by Forlaget Olivia
©Olivia, København 2007

English translation by Cicero Translations
English translation copyright © Search Press Limited 2009
English edition edited and typeset by
GreenGate Publishing Services

ISBN: 978-1-84448-398-3

Drawings: Bodil Nederby
Photos: Kira Brandt
Layout: Sisterbrandt designstue
Cover: Sisterbrandt designstue